74 Ways TO Measure time

			didolosis - p. p
	44		

74 Ways To Measure time

EHUD SCHORI

CiUniverse

74 WAYS TO MEASURE TIME

Copyright © 2015 Ehud Schori.

All rights reserved. No part of this book may be used or reproduced by any means, graphic, electronic, or mechanical, including photocopying, recording, taping or by any information storage retrieval system without the written permission of the author except in the case of brief quotations embodied in critical articles and reviews.

iUniverse books may be ordered through booksellers or by contacting:

iUniverse 1663 Liberty Drive Bloomington, IN 47403 www.iuniverse.com 1-800-Authors (1-800-288-4677)

Because of the dynamic nature of the Internet, any web addresses or links contained in this book may have changed since publication and may no longer be valid. The views expressed in this work are solely those of the author and do not necessarily reflect the views of the publisher, and the publisher hereby disclaims any responsibility for them.

Any people depicted in stock imagery provided by Thinkstock are models, and such images are being used for illustrative purposes only.

Certain stock imagery © Thinkstock.

ISBN: 978-1-4917-7733-6 (sc) ISBN: 978-1-4917-7734-3 (e)

Library of Congress Control Number: 2015915558

Print information available on the last page.

iUniverse rev. date: 11/11/2015

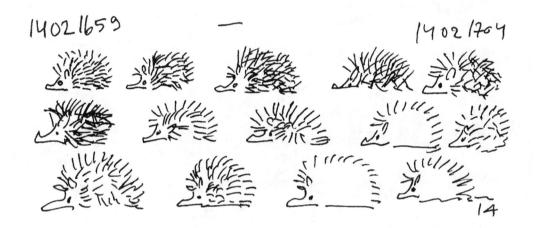

HOW TO MEASURE TIME

The day was February 14. The time was 16:59 when the operator answered my phone call, but it was just after 17:04 when I heard the voice of the man I wanted to speak with. I had to wait 5 minutes. Actually I waited 14 hedgehogs. I still remember the thorns. I drew every one of them.

The drawing above represents the relations between objective time and subjective time. The hedgehogs are actually subjective time units.

More different subjective time units are recorded and drawn on the following pages.

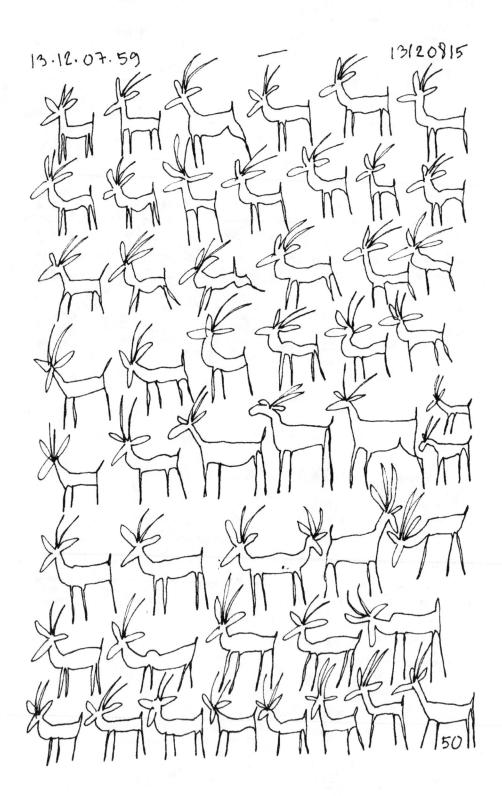

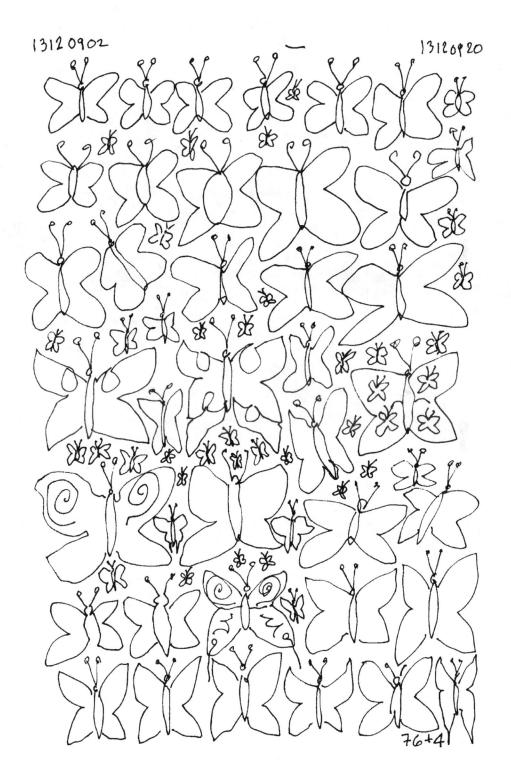

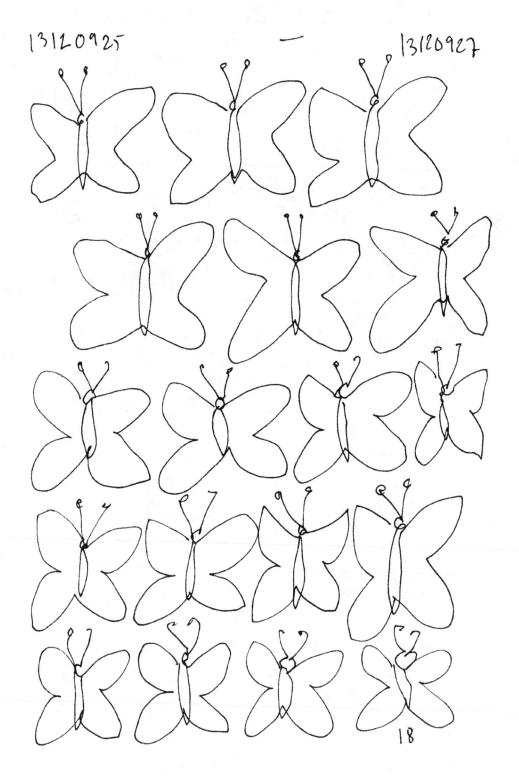

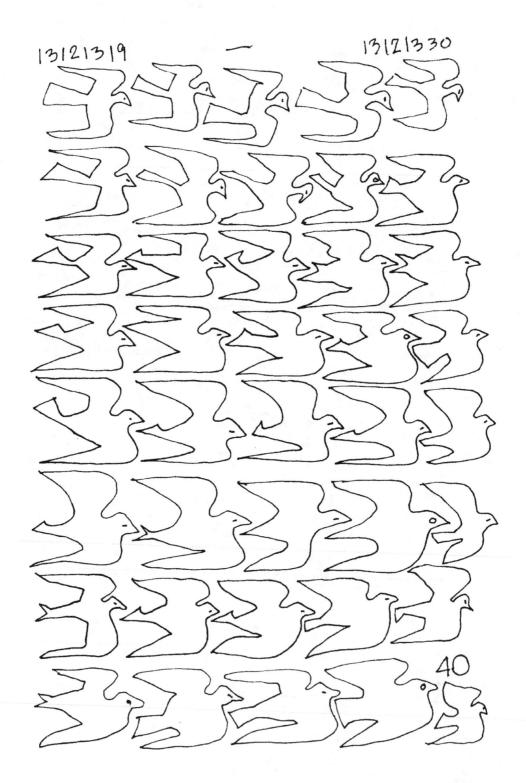

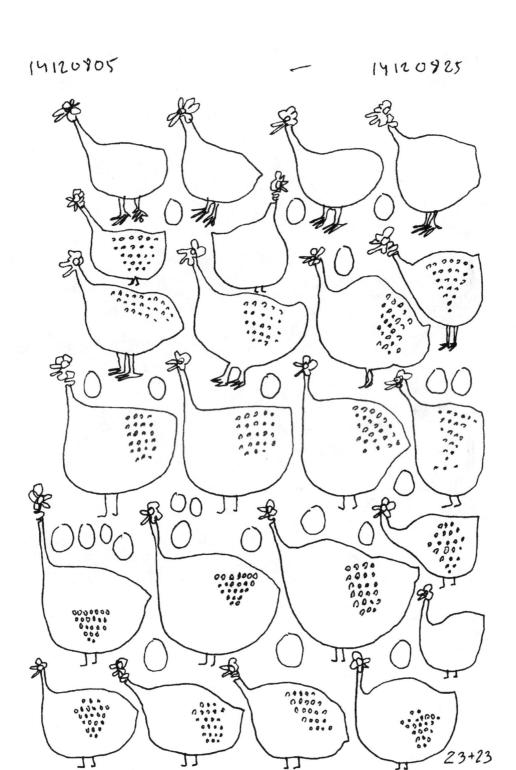

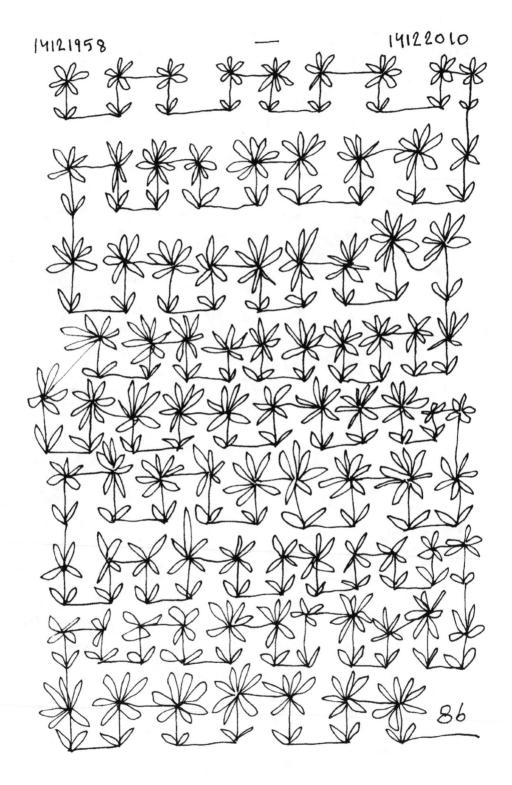

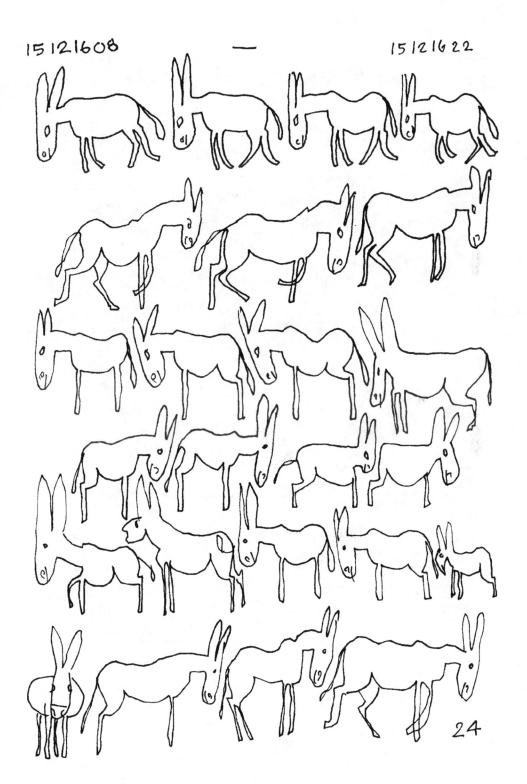

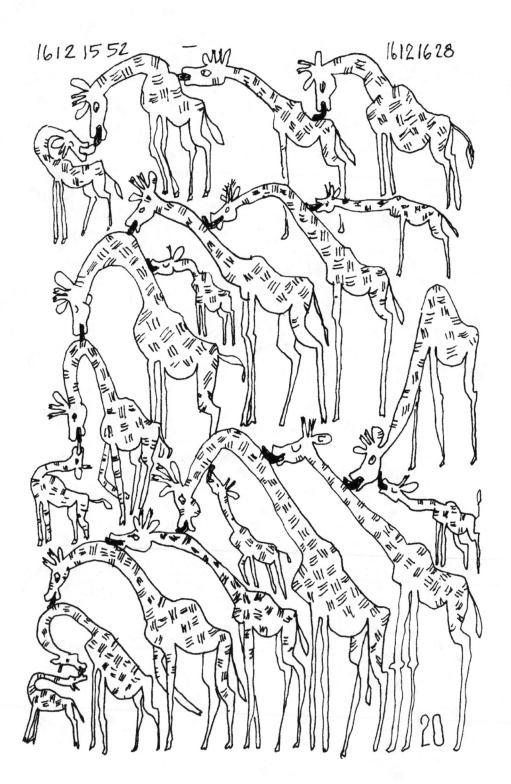

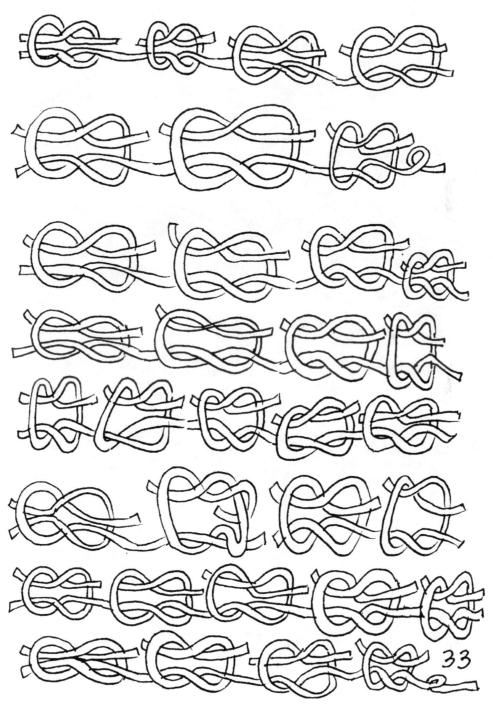

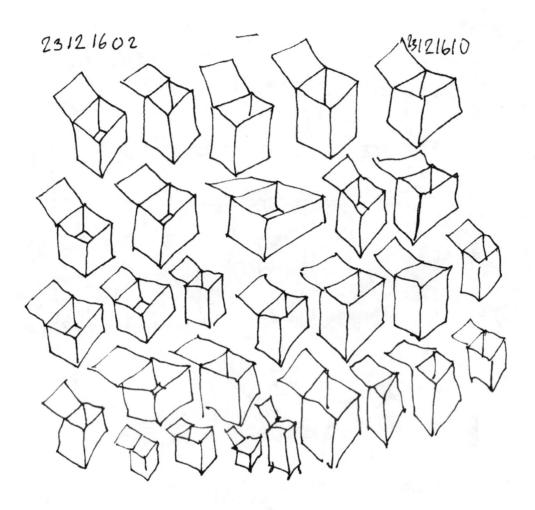

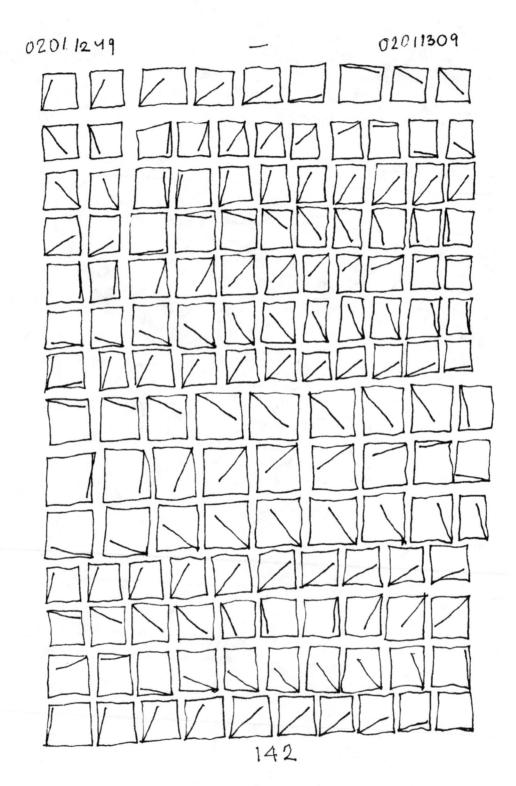

03011355 - 03011408 1 1 1 1 1 1 1 1 1 1 1 VIVIVL < < (/ /) JV VVV/VL <<</// ノノンレレム ニー ンノントトハイノファ 11-11/1477 1/1-11/1/ 1//~~~11/7

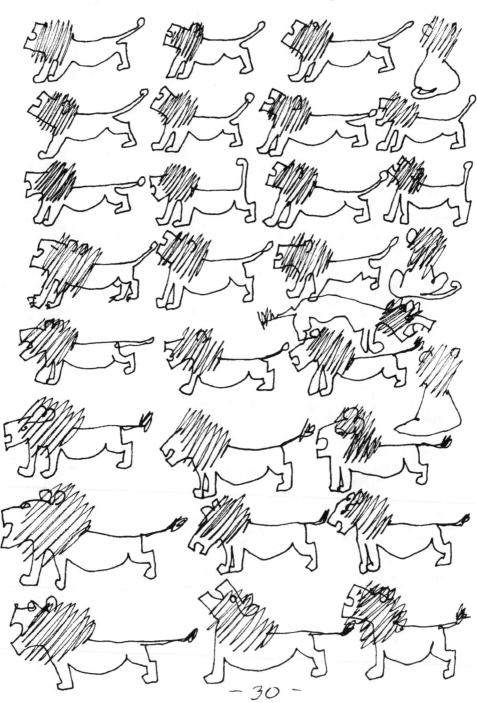

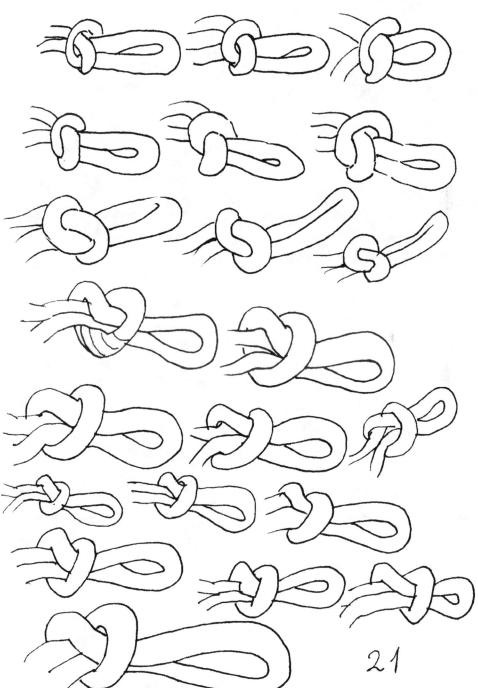

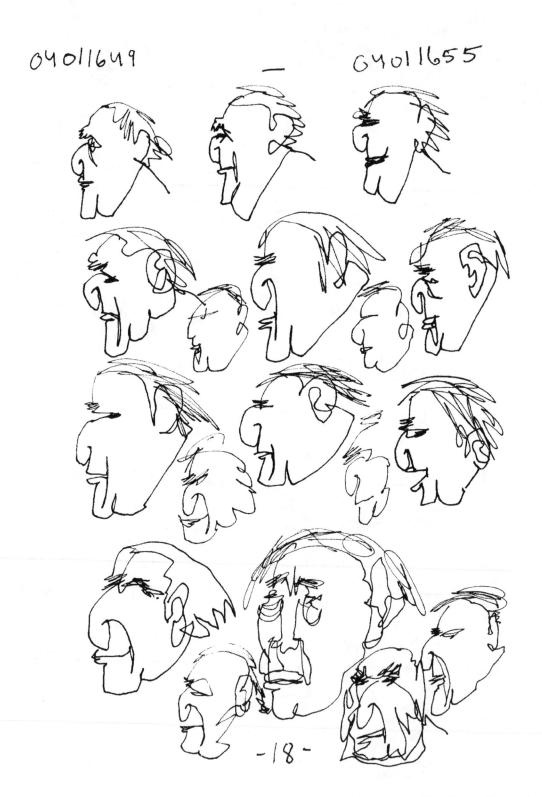

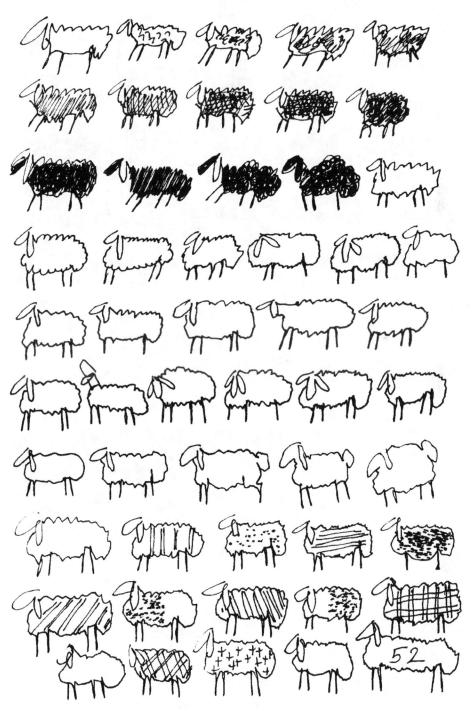

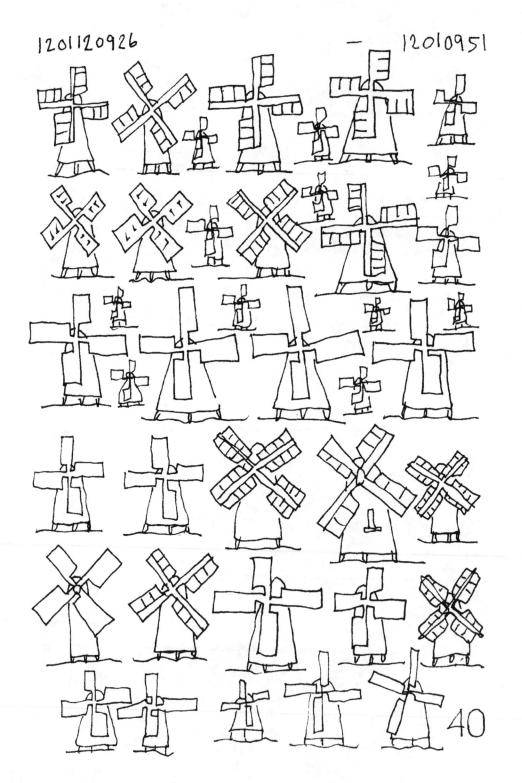

110116 45 11011706 nnnnn nininin nnnnn D m m m 69

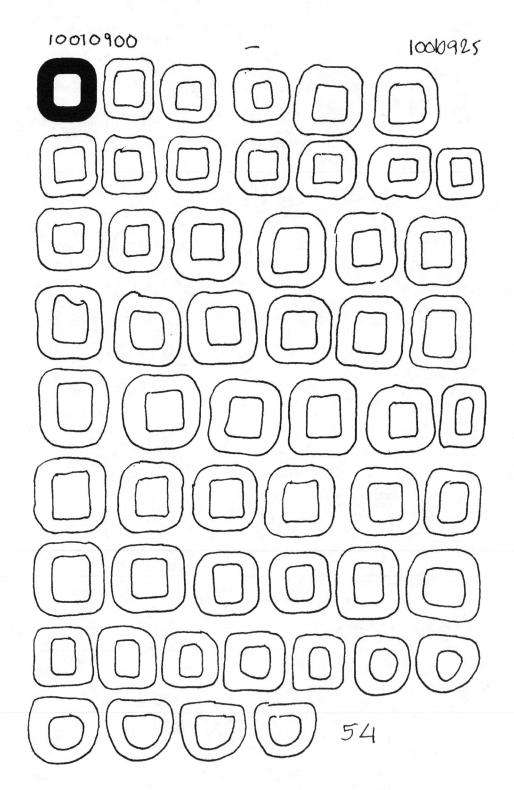

- 67011444

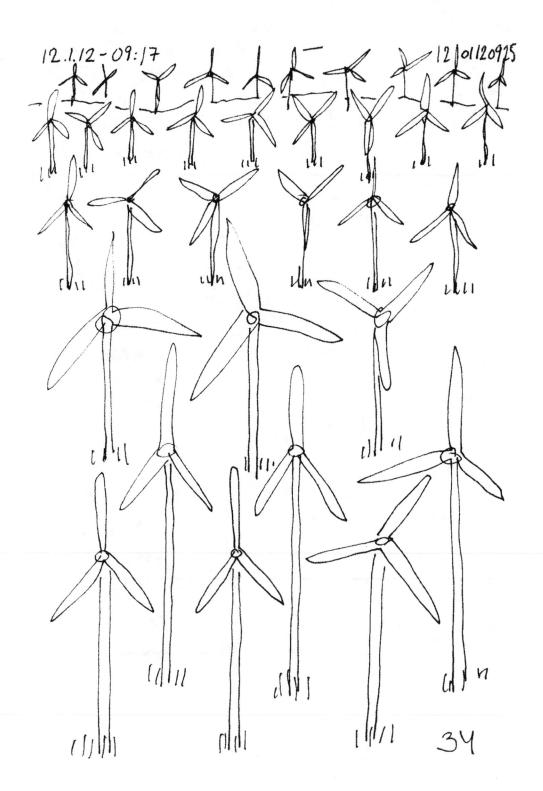

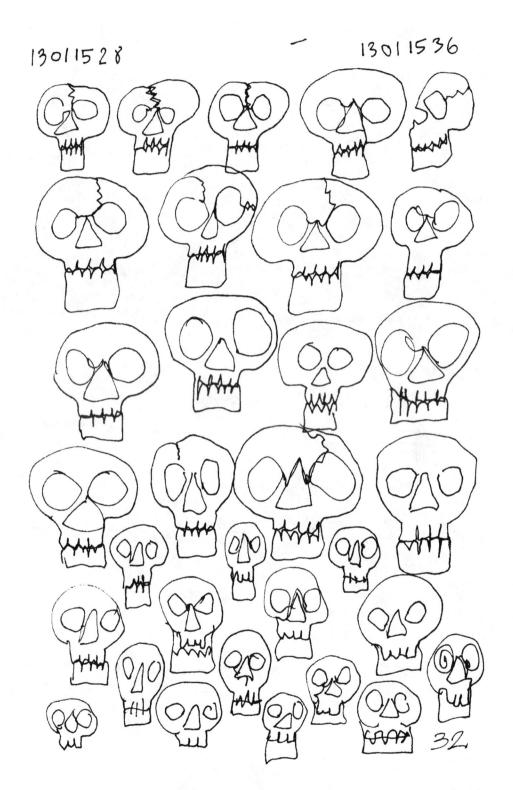

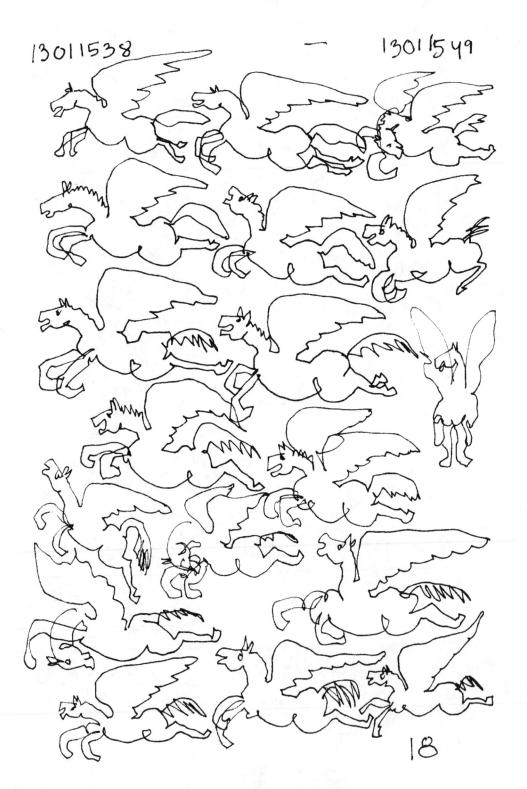

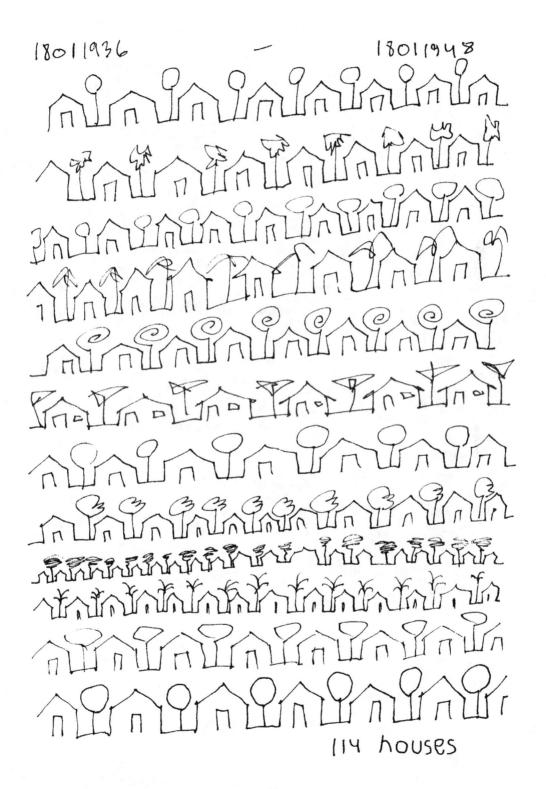

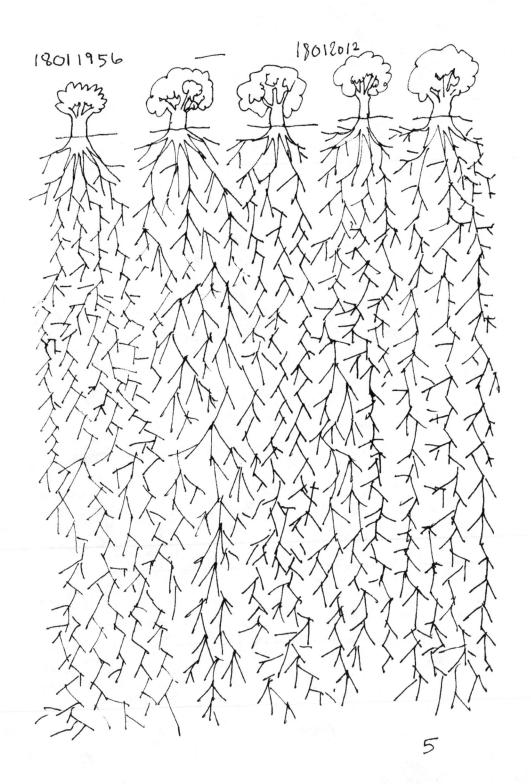

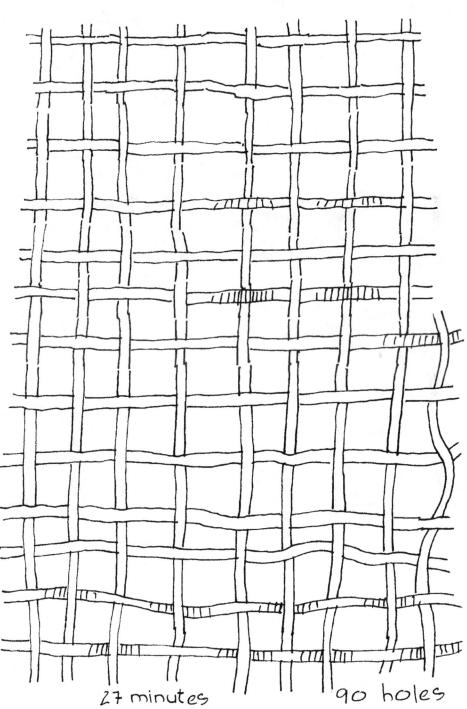

22010844 22010818 现在 经投入 对抗 到级 NEB XXXXX EXXXER YXXX 对现 深深 SISTER STREET 现场积累现象现象 AN KRYKK KRYKK KRY 不不成果 和和 次天文 双 EXXXX DISTINATION RITH RITH RICK 26 minutes 152 figures

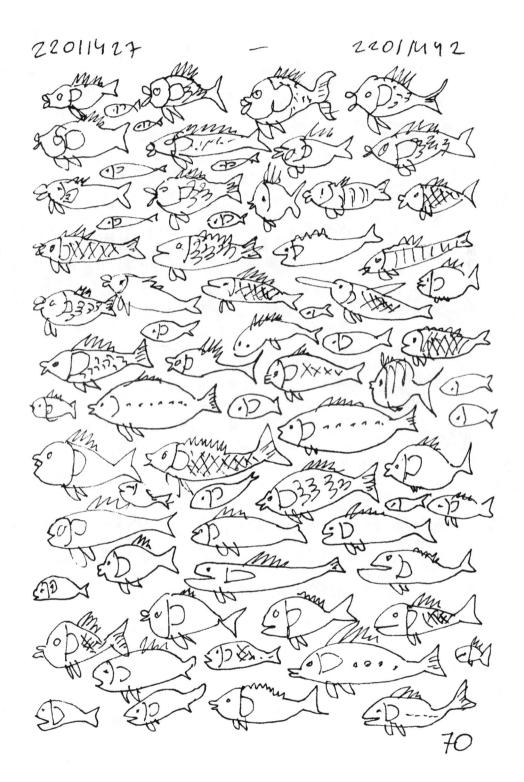

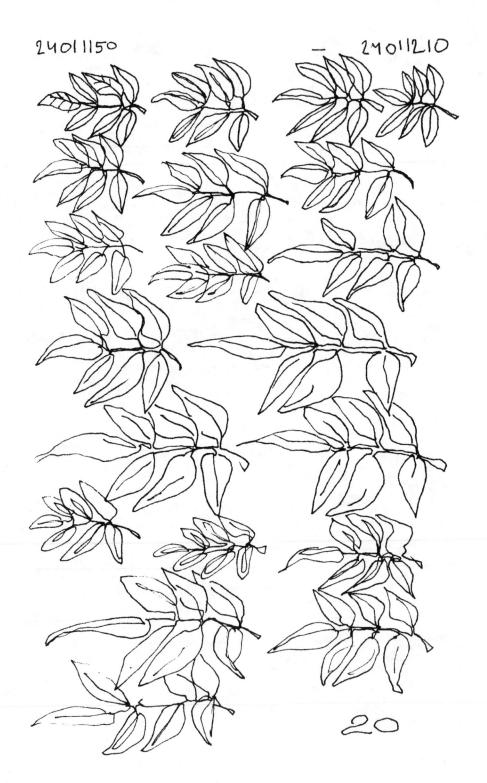

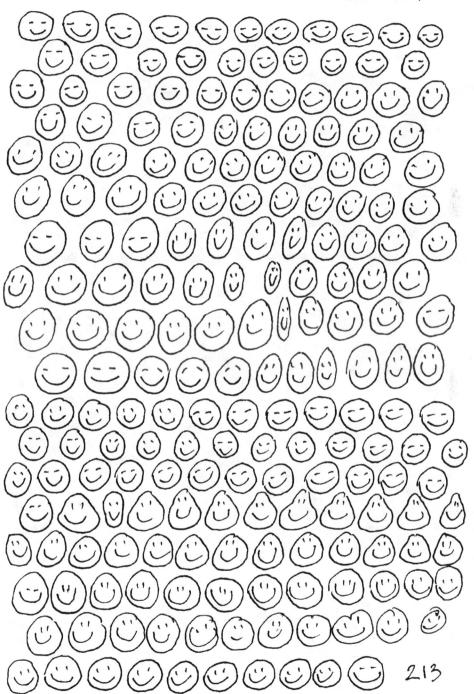

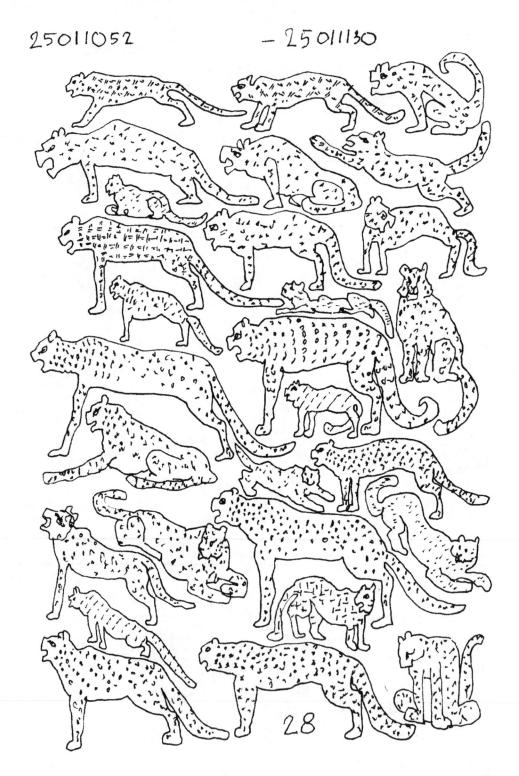

25011543 2501 1555 A B B B B B B B B B 888888888 8 8 8 B B B B B B B B B B B B B B B B B & & B & B & B & B & B & B B B B B B B B B B B B B & B & B 8 8 8 8 8 8 8 8 & & & & & & & & & 2 2 2 2 2 2 2 2 2 2 6 6 6 6 6 al a de de de de de de B B B B B B B B 8 8 8 B B D B B B D B 208 ×3 = 624

盘盘 数 数 数 数 数 翻翻翻翻翻翻翻翻 岛岛岛岛岛岛岛岛岛 岛岛岛岛岛岛岛岛 为品品品品品品品 A B B B B B B B B B B B A A A A A A A A A A A A An De De De De De De De De De & & & & & & & & De Abo De Lo

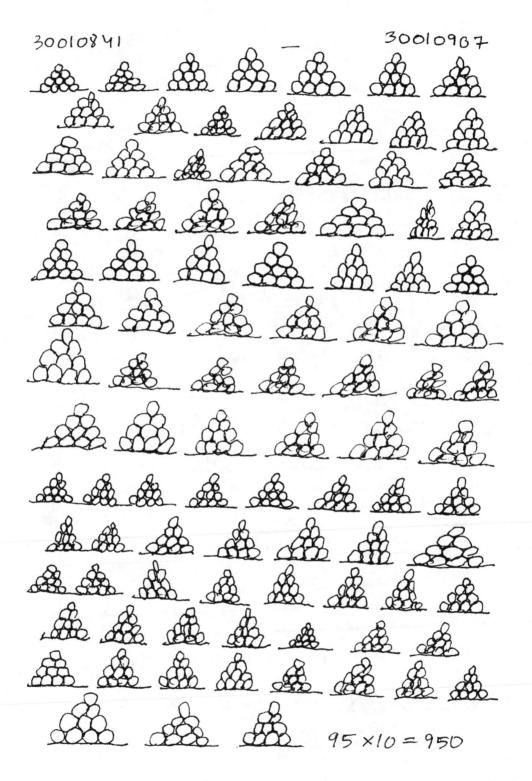

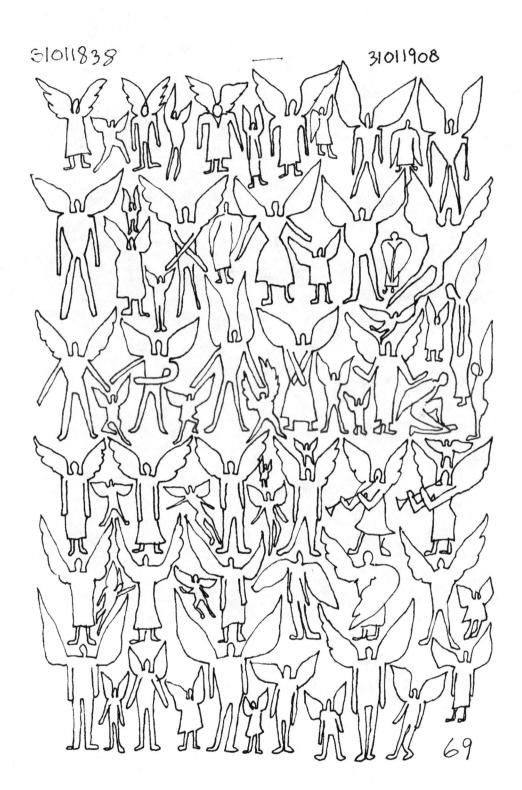

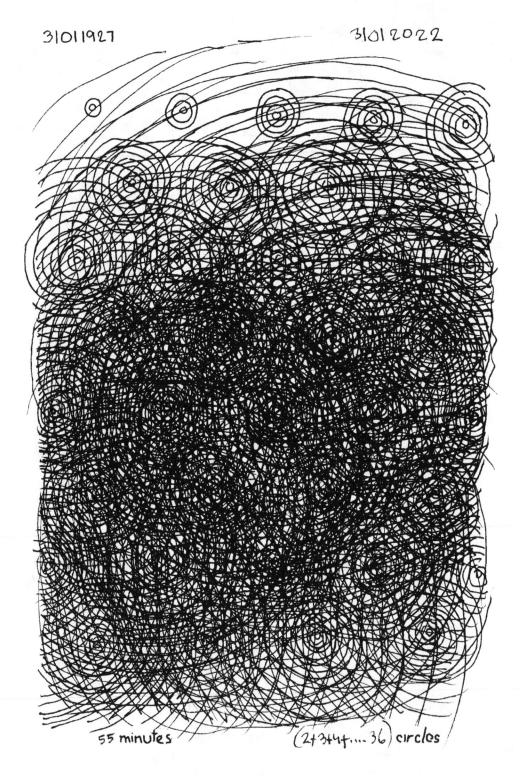

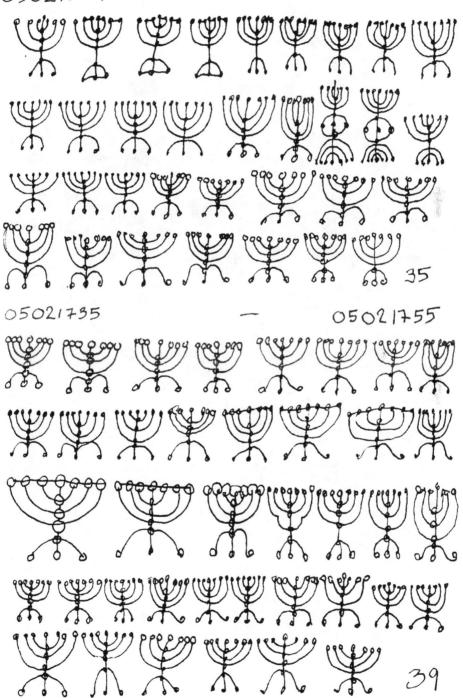

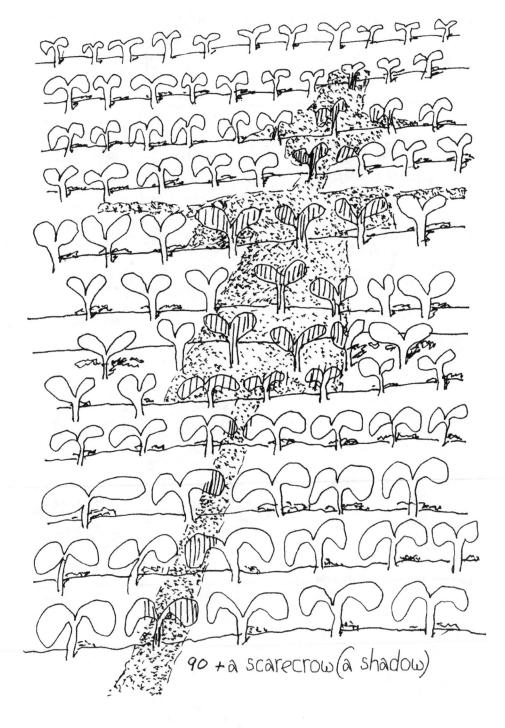

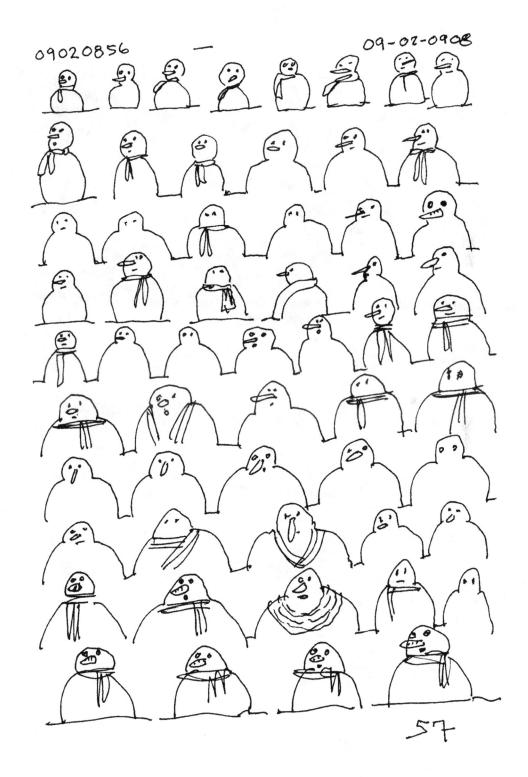

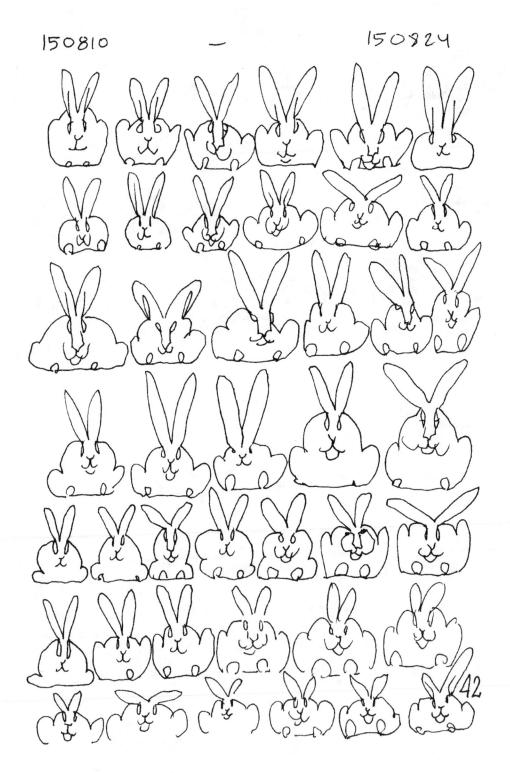

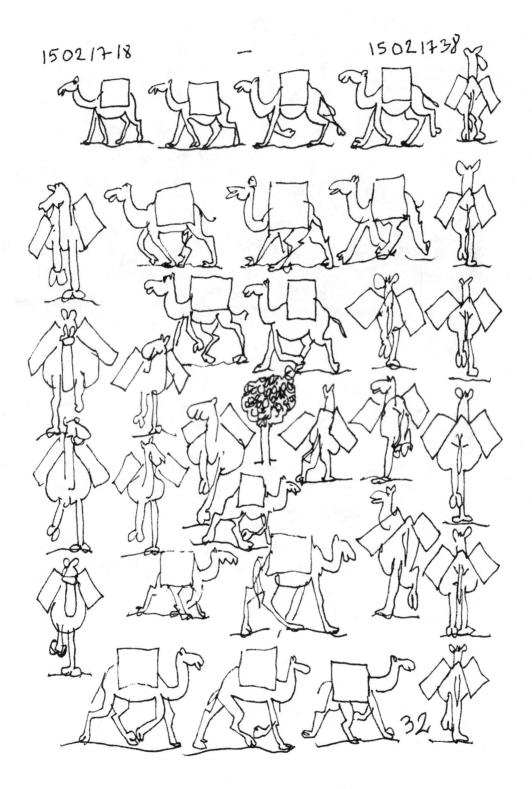

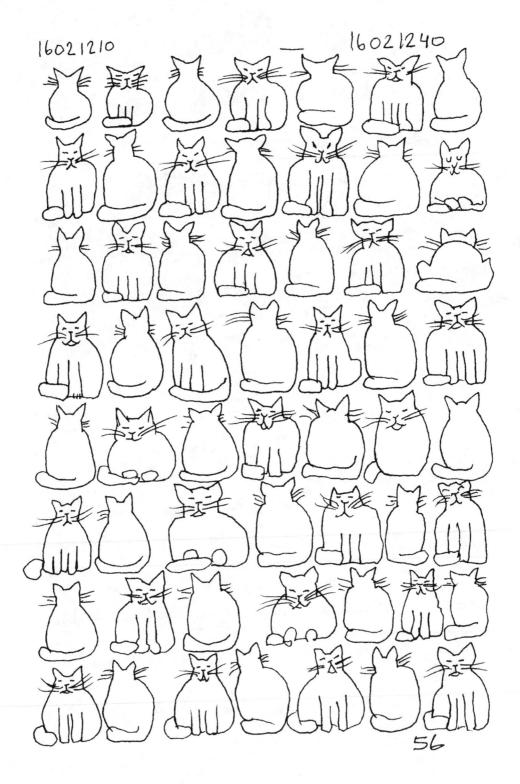

HH # # # # # # # # # # # # # # # # AH IHT HET HET HET HET HET THE HET THE ############# HI HIT HELL HET HET HET THE THE AT HE ATT CHIEF HETT CHIEF HI HE HIT HIT HIT HIT HIT HIT HIT HET AND HET SHETHE ## ## ## ## ## ## ## ## ## ## ## ## HH HH HIT HIT HH HHT HIT HIT HAT HAT HET ELLE HAT EST

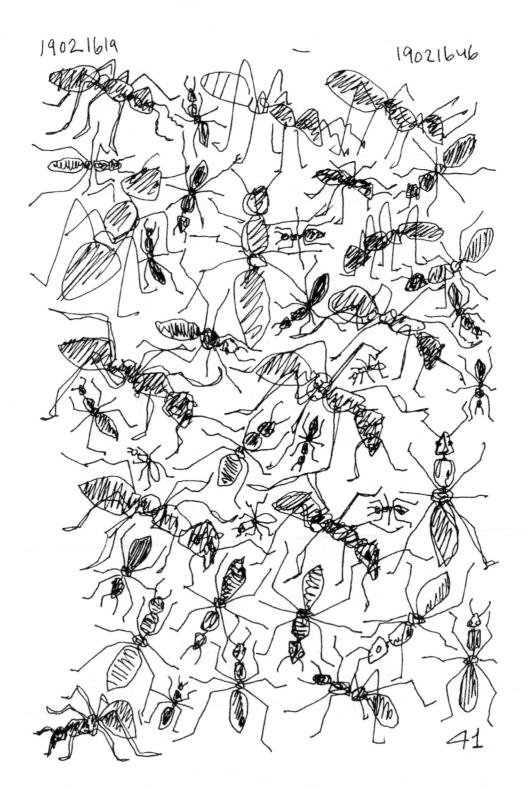

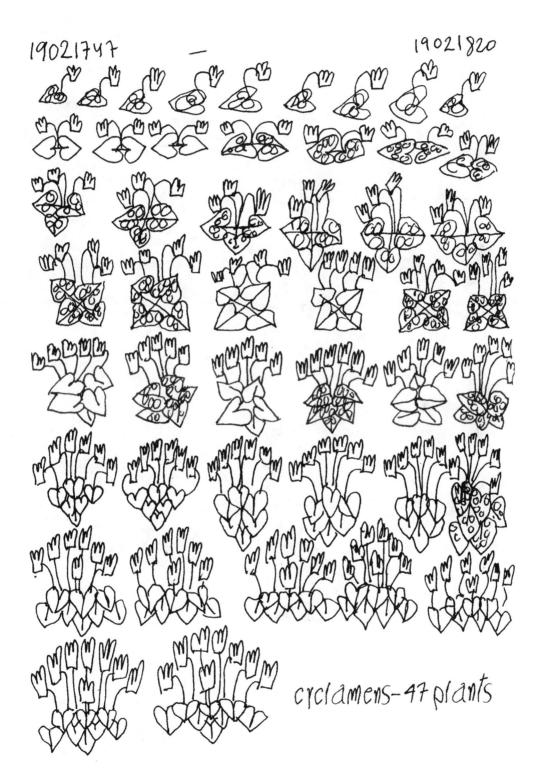

21021733 2102444 合合合合合 百 仓 仓 仓 仓 仓 仓 仓 仓 仓 你你你你你你你你你的 的合合合合合合 的合合合合合合合合合 3个个个个个 民合企合命命命命合合合企 12个个个个个个公公 后合合合合合合合合 16年午午午午午午午午午 各合命命命命命命令命 而合分分分分分分分分分分分 的介介介介介介介 日午午午午午午

少多个个个个个个个个

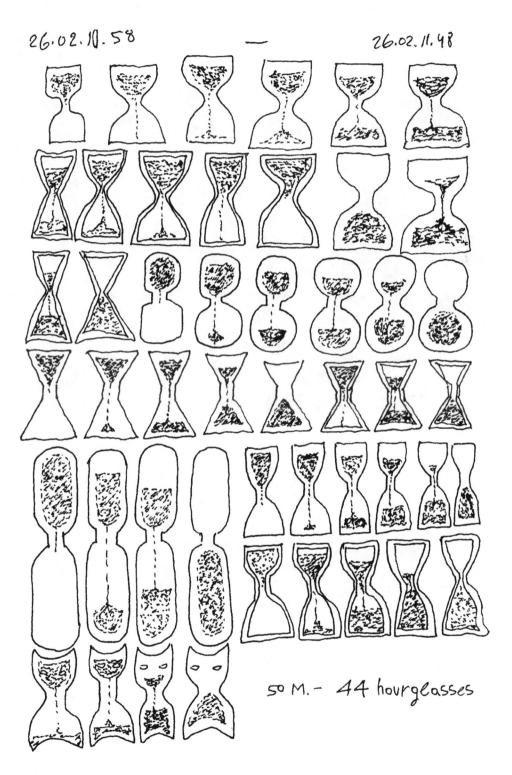

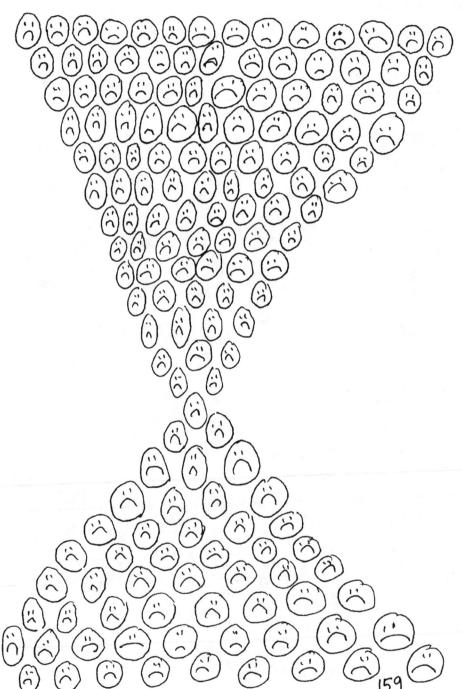

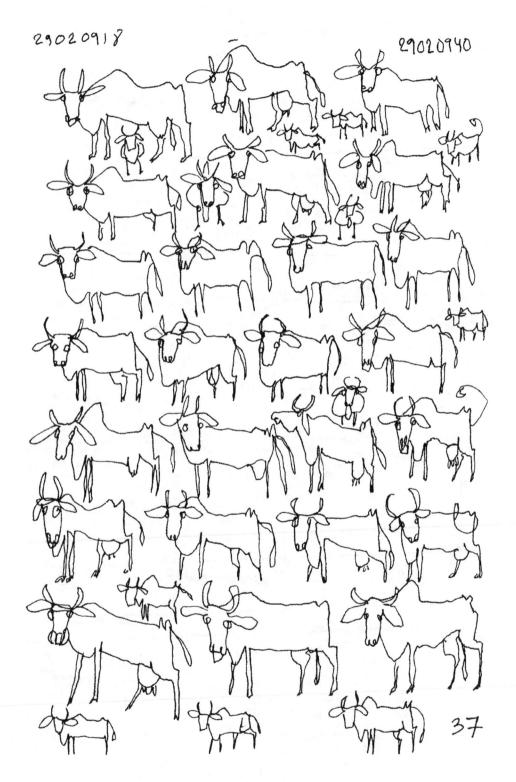

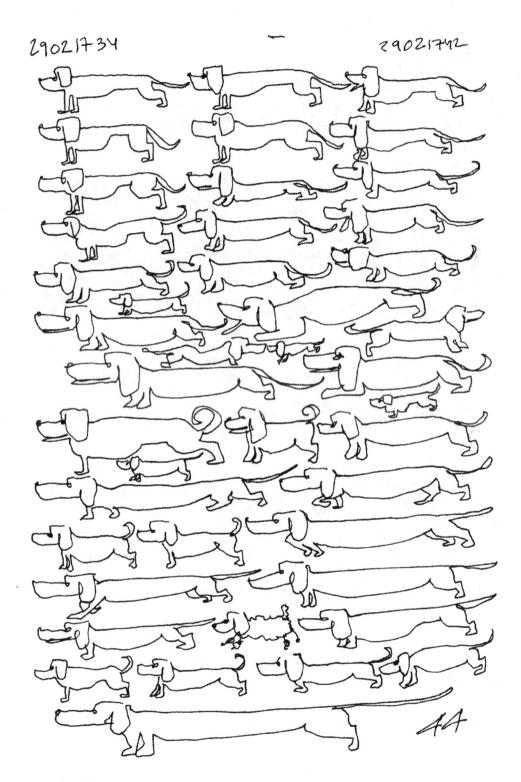

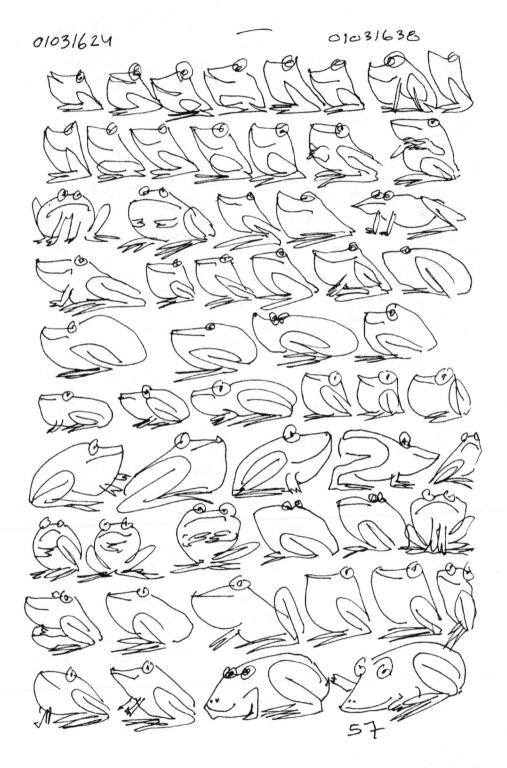

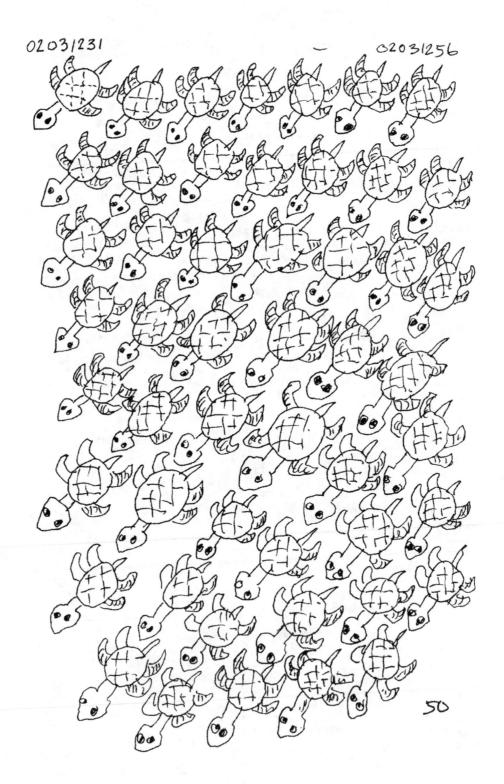

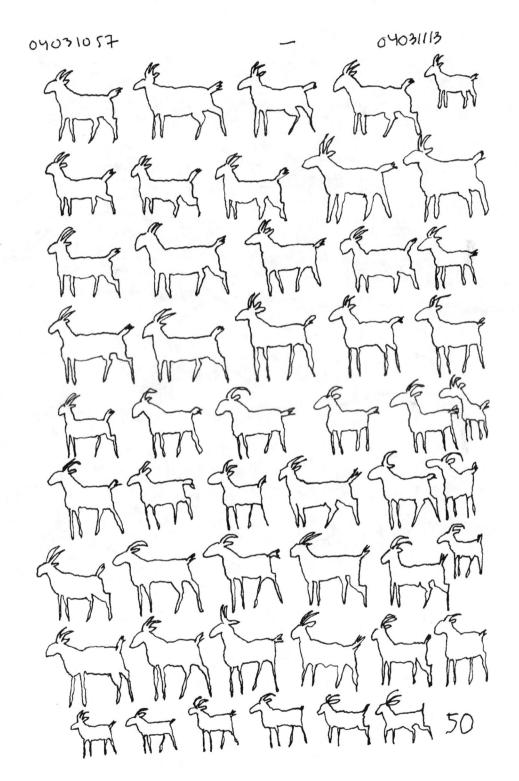

04031352 0403/426 an monda LESSIC ME ATIMON TA Remind TREVI REWITT newns 34 M. 15 words, 270 letters,

How much time is left till the opening

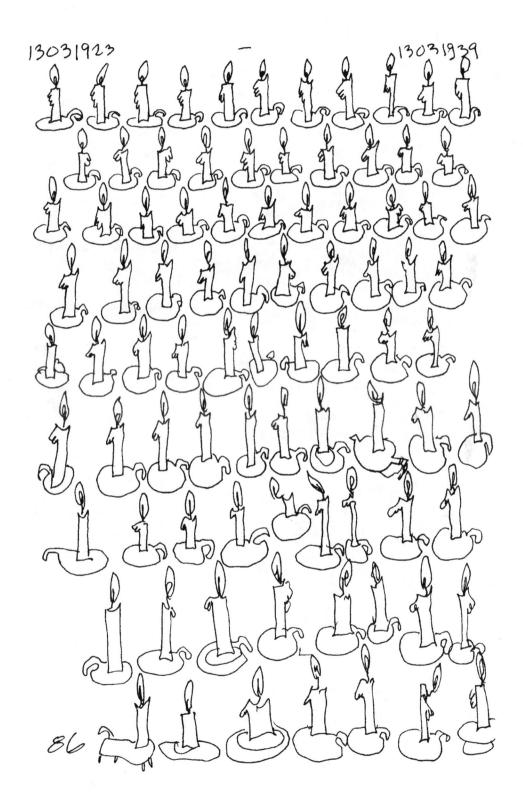

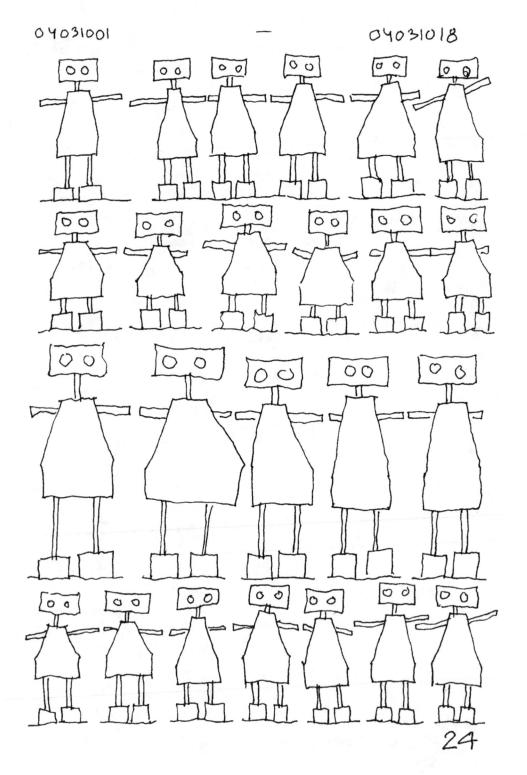

05030935 05031000 כמה דמן עבר מאז הפתיחה של דף זה כמה זמן עבר מאז הפתחה של דף זה (החדש)
כמה זמן עבד מאד הפתיחה של דף זה (החדש)
כמה זמן עבר מאז הפתיחה של דף זה
כמה זמן עבר מאז הפתיחה של דף זה
כמה זמן עבר מאז הפתיחה של דף זה כמה זמן עבר מאז הפתיחה א דף זה כמה זמן עבר מאז הפתיחה על דף זה כמה זמן עבר מאז הפתיחה על דף זה כמה זמן עבר מאד הפתחוש דף זה כמה זמן עבר מאז הפתיחה של דף זה כמה זמן עבר מאז הפתיחה של דף זה כמה זמן עבר מאז הפתיחה של דף זה כמה זמן עבר מאז הפתנודה שלדף זה כמה זמן עבר מאז הפתנודה שלדף דה כמה זמן עבר מאז הפתיחה כמה זמן עבר מאז הפתיחה

How long has it been since the opening of this page

נמה זמן עבר מאז הפתיחה?

JIPT 25

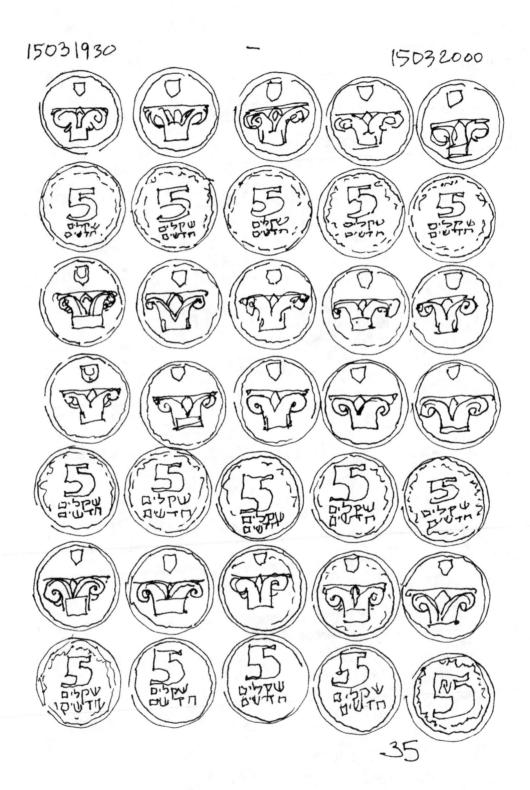

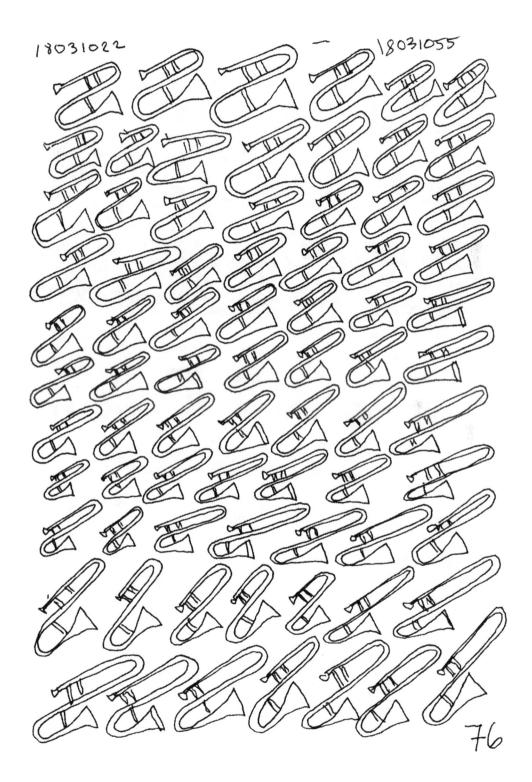

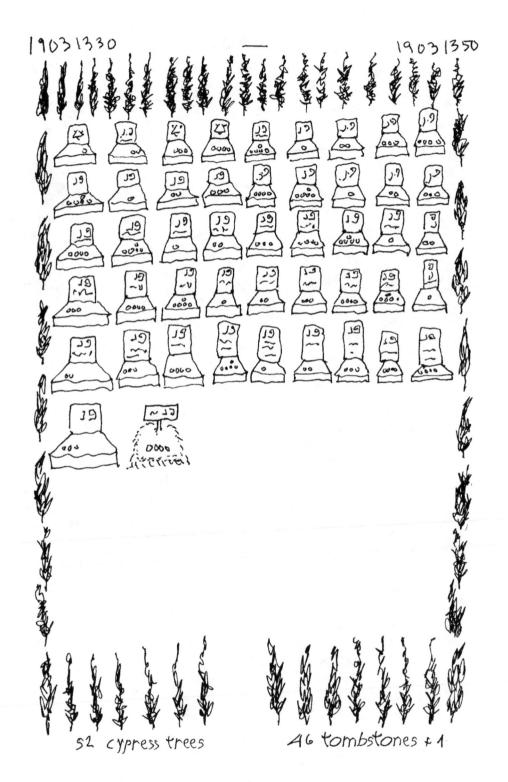

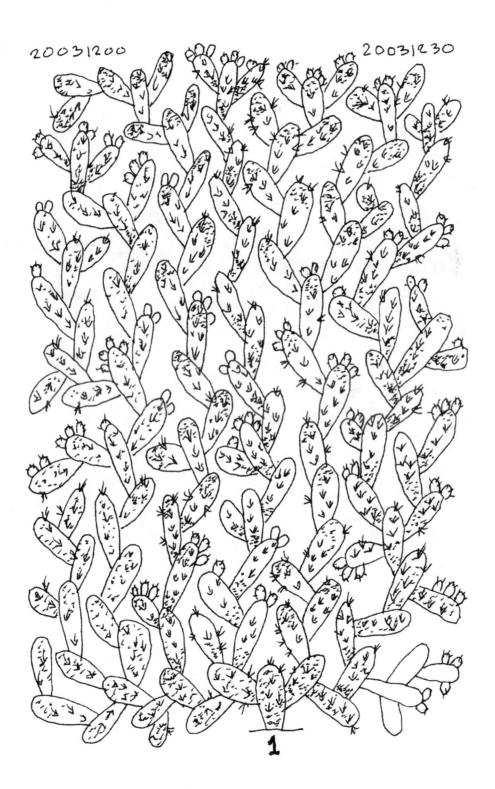

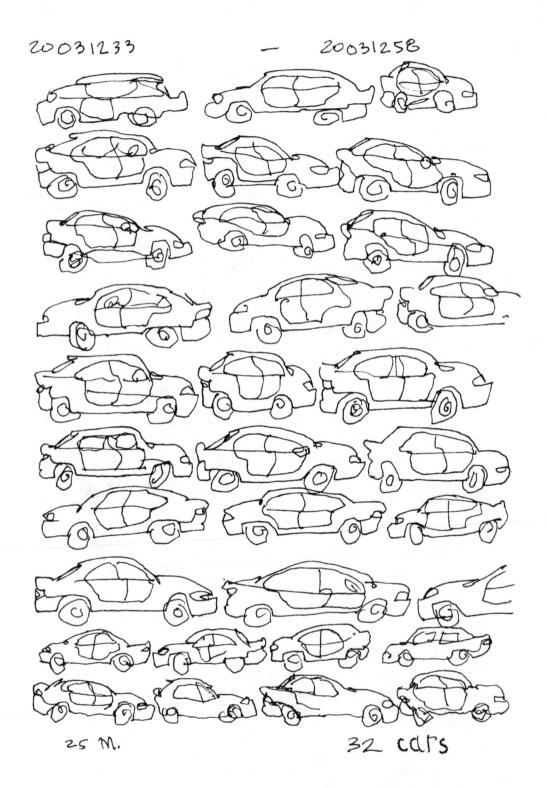

		*	

	*		
		41	